# Coloring
# Mandalas
## for Peace

**Fair Winds Press**
100 Cummings Center, Suite 406L
Beverly, MA 01915

fairwindspress.com • bodymindbeautyhealth.com

FAIR WINDS

# Coloring
# Mandalas
## for Peace

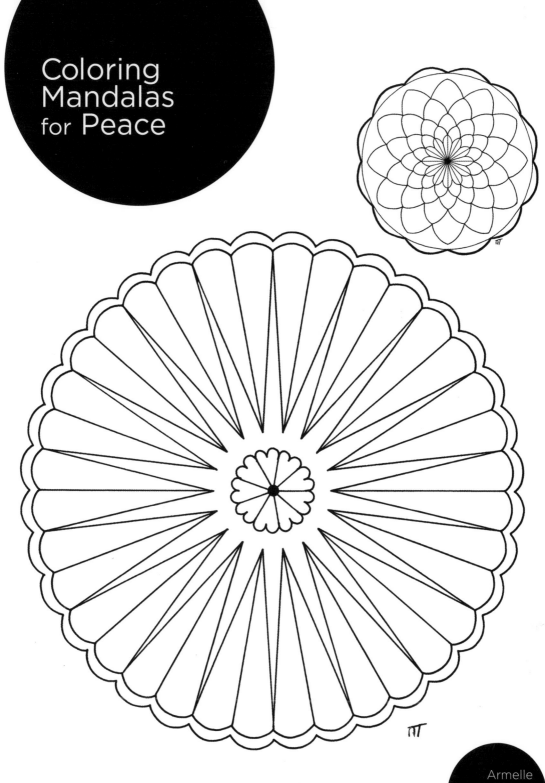

Armelle
Troyon

First published in the USA in 2014 by
Fair Winds Press, a member of
Quarto Publishing Group USA Inc.
100 Cummings Center
Suite 406-L
Beverly, MA 01915-6101
www.fairwindspress.com
Visit www.bodymindbeautyhealth.com. It's your personal guide to a happy, healthy,
and extraordinary life!

18 17 16 15 14 1 2 3 4 5

ISBN: 978-1-59233-656-2

Cover design by Quarto Publishing Group USA Inc.
Book design by Nord Compo, à Villeneuve-d'Ascq

Printed and bound in China

# Contents

# Did You Say "Mandala"?

*Mandala* is a word from India. In Sanskrit, it means circle. Tibetan monks make beautiful mandalas from colored sand. After spending several hours, or even several days, building them, they blow them away. The ephemeral nature of their mandalas reminds them of the power of the present moment. In Indian villages, women draw mandalas in front of their door every day with rice flour as a sign of harmony and peace. In fact, mandalas are found in every culture. In Europe, you can see superb mandalas in cathedrals with their beautiful rose windows. The form can also be found in many genres: the decorations of the Andalusian palaces, jewelry, plate and tray design in Morocco, African wall-hangings, Turkish rugs, Hindu temples, fountains, and so on.

# What Is a Mandala?

A mandala is simply a drawing with a well-defined center surrounded by a periphery. It is a universal shape found in a great number of cultures as well as in the natural world. Fruits (for instance, oranges or tomatoes) and vegetables (carrots, zucchini) can contain wonderful mandalas: you only need to cut a slice to see it appear. Cobwebs, flowers, the solar system, trees, snowflakes, water molecules… when you start looking you realize that nature is an infinite source of mandalas.

Our ancestors understood the benefits of the mandala form. They used to build their villages using that very structure: at the center, the square, a place for exchanging goods and ideas, the place where people gathered to talk with each other, hear opinions, and get advice. The center is also the place where the church or spiritual site would be built. The periphery, on the other hand, is represented by the boundary wall, offering security, with the doors closed at night to protect the inhabitants. In Ardèche, a southern district of France, many of the old villages have this organization.

In some cultures, the houses themselves adopt the mandala form: Mongolian yurts, American Indian tepee, African huts all have the hearth at the center so inhabitants can gather at the center.

The circle was also used in healing rituals and traditional dancing, its center marked by a symbol or a person.

In the microscopic world, the human cell can be seen as a miniature mandala: the center is the nucleus that contains our DNA, i.e. the "resource point." The periphery is the cell membrane that stops intruders from entering the cytoplasm, therefore providing security. Let's go even further: with its symmetrical structure around a central axis—the spinal column—the human body is also a big mandala, especially since it is made of cells and water molecules.

# Letting Go with Mandalas
## A Relaxing Form

Try the following experiment: find an image of a cathedral rose window. Your eye will automatically focus on the center and you will be able to see all the elements that make it up without having to move your eye. Then, find an image of a stained glass window with scenes and characters from the Bible: this time, your eye will be moving around a lot looking for all the different parts of the image.

As another example, try coloring with small children. If you give them an image that represents a story, they will invariably start by coloring a bit of the sun, a bit of each of the characters and so on. If you give children a mandala, however, their eyes will immediately be drawn to the center and their coloring will begin there.

Like rose-windows, the mandala is a relaxing form that allows us to calm ourselves by focusing on the resource point.

## Finding Cerebral Balance

The mandala form allows you to find peace and recenter yourself. Coloring it helps you reach a form of cerebral balance.

In the region of the neocortex, we have two hemispheres that we also call our Left Brain and our Right Brain.

- **The Left Brain** sees everything in detail. It needs to be rational, to explain everything, to understand everything, to put everything in boxes. It is the side of the brain that handles space, time, and speech. It is the cerebral side, and processes laws and logic. It is the "adult" side of our brain, practical and for the day-to-day, allowing us to act. It is the energy that we call "masculine".

- **The Right Brain** ,perceives everything globally. It is a generalist and is the side used for imagination, intuition, and sensations. It is the hemisphere of creativity and inspiration, our "inner child." It is the "feminine" energy which lives inside each of us.

| Left Brain | | Right Brain |
| --- | --- | --- |
| *Sees everything in detail* | | *Sees globally* |
| Logic<br>Deduction<br>Planning<br>Verifying<br>Handling space, time<br>　　and speech | *The communication between the two hemispheres takes place in the corpus callosum.* | Intuition<br>Creativity<br>Arts<br>Imagination<br>Feelings<br>Inspiration |

These two hemispheres function in different ways, but neither is "better" than the other; they are complimentary.

Nature is permanently seeking balance, and as we are part of nature, so do we. Ideally, the two sides of our brains should work equally. The worlds of school and work mostly require use of our Left Brain. We have to be profitable, productive, efficient, and rational; know everything and be able to explain everything. There is little space for the Right Brain, the side of intuition and imagination. To balance this, we use hobbies and activities to rejuvenate ourselves by using our Right Brain and letting the Left Brain relax.

This means we are constantly moving back and forth between the left and right hemispheres. If we are constantly busy, always chasing success and results, we risk becoming exhausted. On the other hand, if we live too much within our imaginations, we struggle when it comes to daily life and reality. The ideal solution, therefore, is to use both the Left and Right Brain at the same time.

Mandalas allow us to find this cerebral balance. When you chose your drawing and your colors, you are using your Right Brain, the side of imagination and creativity. But a mandala isn't just any drawing: it is a highly organized drawing built upon a structure in which you color every detail.

You are processing space and symmetry, using logic and deduction, and therefore using your Left Brain as well. With the two sides of the brain working at the same time, connections take place in the corpus callosum (see table, p. 10) and you are able to get energy back from the hemisphere you use less on a daily basis (we all have a dominant hemisphere). This process allows you to achieve cerebral balance, the source of well-being.

Because mandalas let us recenter ourselves, they push away interfering thoughts. You are with yourself and you are able to let go.
•If you are always active, working against the clock and being stressed, mandalas help you rediscover your intuition, your creativity, and your desire to be peaceful.

•If you have children who are always daydreaming and imagining their own little worlds, mandalas will help them connect with the energy of the Left Brain, making them more receptive to learning.

You can find a lot of mandalas on the Internet. In fact, creating a mandala using a drawing application on a computer is very easy: one click and you can reproduce your motif as many times as you like. However, these will be identical reproductions: fifty birds, fifty flowers, fifty circles, they will all be the same. This does not exist in nature and leads to the misconception that perfection is possible.

Mandalas drawn by hand are imperfect; each contains little differences that make it more similar to the real world—alive and vibrant.

Beware of some mandalas for children that have large drawings of people or animals at their center. In this case, the eye doesn't know where to look and chooses a detail that might not be in the center of the mandala. The result will be less effective or perhaps have no effect at all.

# Who Are Mandalas for?

Coloring mandalas is a good activity for everyone, bringing benefits to children and adults, teenagers and seniors alike. It is used more and more in schools, retirement homes, and hospitals, and when it comes to dealing with disabilities, mandalas can also be of great help.

In workshops and teaching classes that I give, I have received feedback from teachers and health workers who report great results. With autistic children, for instance, mandalas restored an element of communication. For physical rehabilitation patients, mandalas seem to speed up recovery and they help people with severe illnesses cope with hospitalization. In retirement homes, too, mandalas help to keep minds active. It is thought that seniors with Alzheimer's can even recover elements of their ability to process time and space, and more importantly re-establish a desire to communicate, by coloring mandalas.

Coloring mandalas is a great family activity, rich in social connections. It allows families to have more open and honest dialogue between parents and children or teenagers. If you color with your small child or your teenager, they will feel as if they are talking with someone who accepts them at their level, rather than in a situation where the adult is superior. Important matters can be discussed quietly around a table when every member of the family is coloring a mandala.

Children can color mandalas from around the age of three. They immediately connect with the form. It doesn't matter if their coloring isn't perfect; the pleasure of the act and its intention are what matters.

# When Should We Color Mandalas?

Obviously, there are no rules as to when you should color. You can color a mandala whenever you like, no matter the time, the day of the week, or the circumstance. Because you feel like it, because you feel the need to calm down for a few minutes, because you need to recenter yourself in the middle of a particularly active or upsetting day—or just for fun! Coloring a mandala is a form of dynamic relaxation and should be done whenever you need to let go.

I also advise that you color mandalas before making any big decision. While coloring, you place yourself in a state of cerebral balance and you will find it easier to make good decisions when connected as much to your intuition as to reality and the material world. Moreover, you will be focused on yourself and will be less influenced by what other people might have said.

Do you need to finish your mandala in one session? No, of course not. Just ten minutes is enough time to feel the benefit of coloring a mandala. You can continue your coloring the next day or later on. I do advise, however, that you finish one mandala before beginning another one. This is especially the case for children. As an adult, the mandala you choose really matches your interior state at a particular moment, so if you realize a mandala you have started doesn't really suit you, you can start a new one and have two or three on the go. But you should always have the intention to finish them all.

# How Do I Choose My Mandala?

Nothing is simpler than getting started. Go through your book and see which drawing attracts you. Try to ignore the logical side of your brain always ready to tell you, "This one is too complicated" or "You like nature—choose the one with flowers." Choose your mandala with your heart, not your head.

In this book, you will find a wide variety of forms and topics. Depending on your mood or your energy in a particular moment, you will be attracted to different things. Maybe the geometric motifs will attract you when you're tired or the round forms will appeal to you when you're angry. Perhaps the childish motifs will appeal to you when you want to reconnect with your memories. Whatever you choose in the moment, don't judge yourself.

You may know that starting with the periphery will allow you to recenter yourself, relax your mind, and find your axis, whereas by starting with the center you will open yourself up and regain energy. However, you don't need that knowledge: the intervention of the mind is not necessary. Let your hand spread the colors where it is led in the moment. .

If you are coloring as a shared activity, always offer several mandalas to choose from, even to children. Everyone needs to find a mandala that they respond to intuitively in a particular moment.

## Coloring Mandala

The same is true for choosing colors. Each color has an energy and a meaning for each different person. Some mandala guides interpret the meaning of completed mandalas based on the colors chosen by the person. Personally, I don't think this is a good idea. My experience shows that everyone has their own history; each color speaks to each person differently. For some, red means energy, for others it brings to mind love or blood or pain.

Again, if you let your hand and your heart choose, you will go toward colors that are good for you in the moment. Children do this spontaneously. And your body knows to guide you towards bright colors if you need energy or towards

soft, cold colors if you need to calm down. Trust yourself to match colors beautifully. A cow can be green and a daisy can be multicolored! The experience you go through while coloring is more important than the result. This is why you won't find examples that have already been colored in this book.

Similarly, you can use ball-point pens, felt-tip pens, paints, pastels and so on. No matter the tool, the point is to be attracted intuitively toward what you feel. Just make sure you have quality tools so you feel even more pleasure.

It can also be a rewarding activity to complete a mandala with little cut-out or drawn characters, or write a few words or sentences within it. Some mandalas are very simple, so this is a means of personalising them even more.

> You don't have to fill the entire mandala. You can decide it is finished even if there is a little bit of white remaining: an empty space is a space for welcoming new things

## The Energy of Mandalas

The colors, the forms... You will very soon see that each mandala has its own energy.

A mandala can be drawn with a particular intention, as an aid to making a decision, for decorating a room, to be sent as a gift, in putting together a project, to free yourself from a weight you have on your heart, to ease your mind about a particular trouble, or quite simply to sleep more easily

> I once had feedback from someone who was just about to launch her company. She worked all day long but couldn't switch off at night. She found the solution was drawing a mandala before bed time. Her mind was able to let the day go and she could have a good night's sleep.

Once your mandala is done, take some time to look at it. If you don't like it or have colored the mandala to free yourself from something, just throw it away. More often, however, we like the mandalas that we color very much. If this is the case, it is a good idea to keep them in a scrapbook and build up an album over time.

If you really like a particular mandala, you can cut it out, stick it on a colored background, and frame it so it can be put on the wall where you can continue to benefit from its energy.

A beautiful mandala brings harmony to a room. Use mandalas for decoration and they will bring calmness and serenity.

# Ephemeral Mandalas

Either as a solitary pursuit or in a larger group, the ephemeral mandala is another path to explore. Go on a walk and pick up all sorts of objects from the natural world: leaves, berries, flowers, herbs, stones, feathers, branches, shells, and so on. Outline some circles on a round table or on the floor and define the center of your mandala, then place the materials you have gathered onto the form. The results are often wonderful! Take a photo as a memento and then disassemble it.

You can also choose a theme or a color, and even make an edible mandala. If you do this with friends and family, you will see it is a great moment of connectivity. You have to agree on things, and everyone from the youngest to the oldest can join in.

## Mandalas Day-to-Day

My advice is to take this book everywhere you go. As children do, color every time you feel like it, just because you have the opportunity and the desire: in a waiting room, on a bus, on the beach, in a car, in the office, in the garden…

If you practice coloring mandalas regularly, you will see a gradual evolution in your choice of drawings and colors. But more than that, you will feel begin to feel a sense of balance within yourself. You will learn about yourself and you will eventually be able to let go more easily. Coloring mandalas is an excellent activity for day-to-day life allowing you to access your inner resources and to return every minute to the essentials of life.

Don't hesitate to photocopy your favorite mandalas onto 8.5 x 11-inch (A4) paper. This way, you can keep them clean in your book, and you will be able to redo them from time to time.

# 200 Mandalas for Coloring

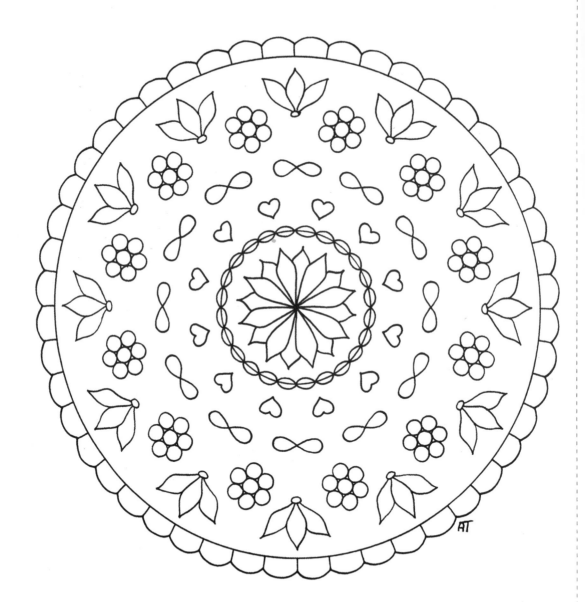

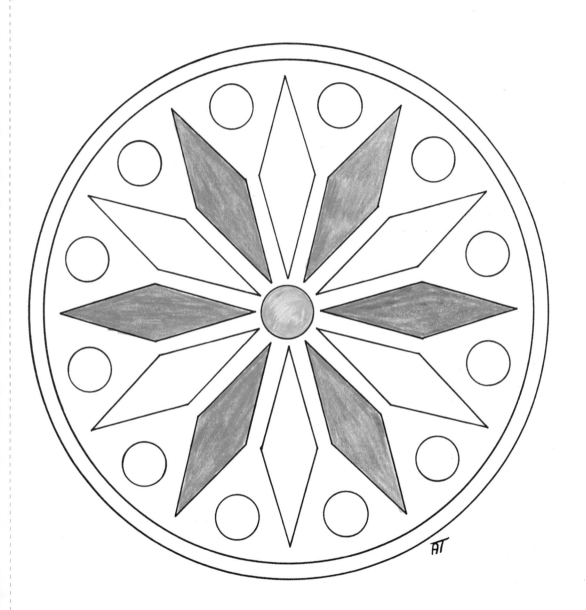

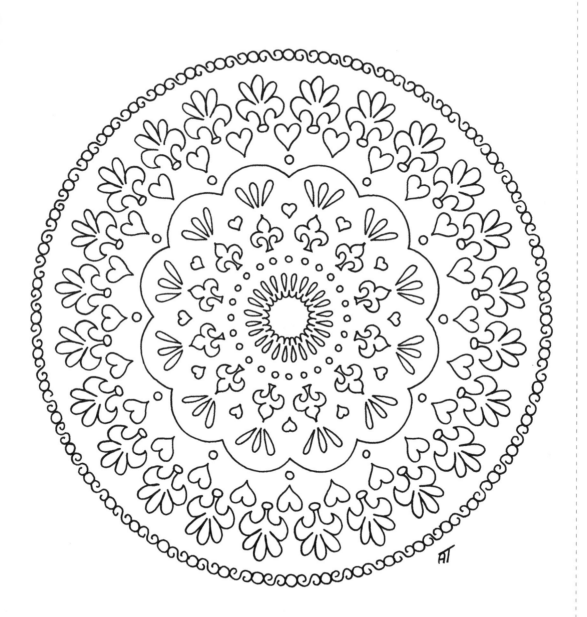

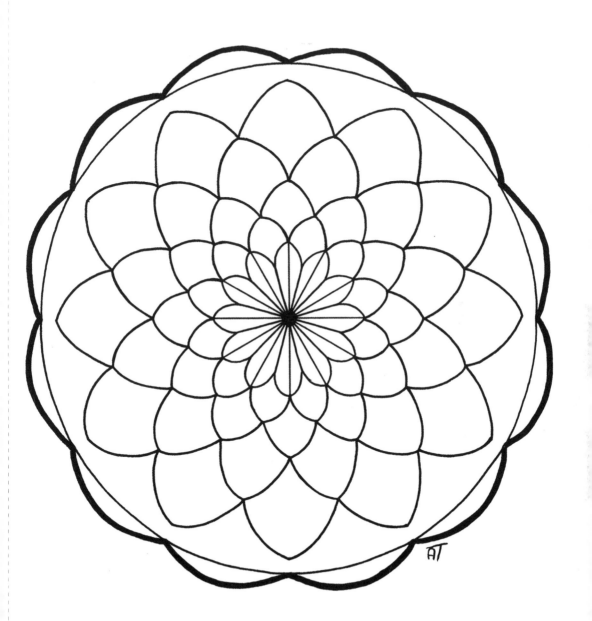

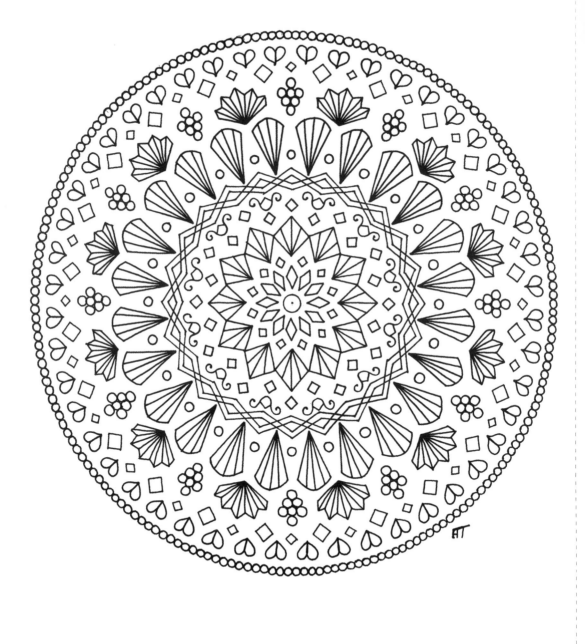

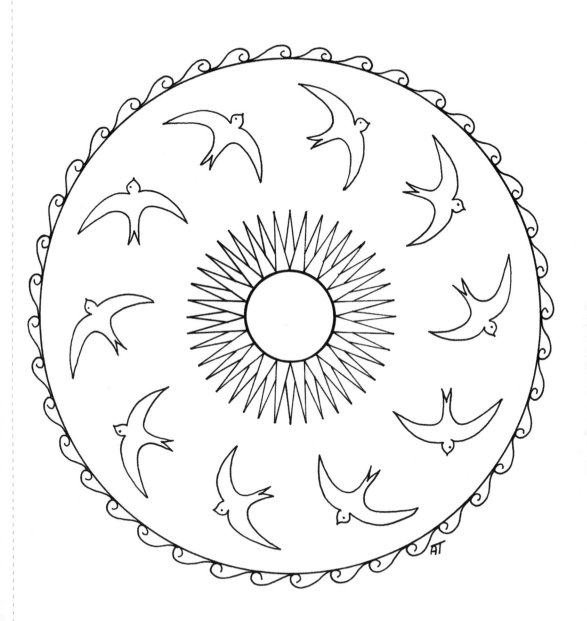

AT

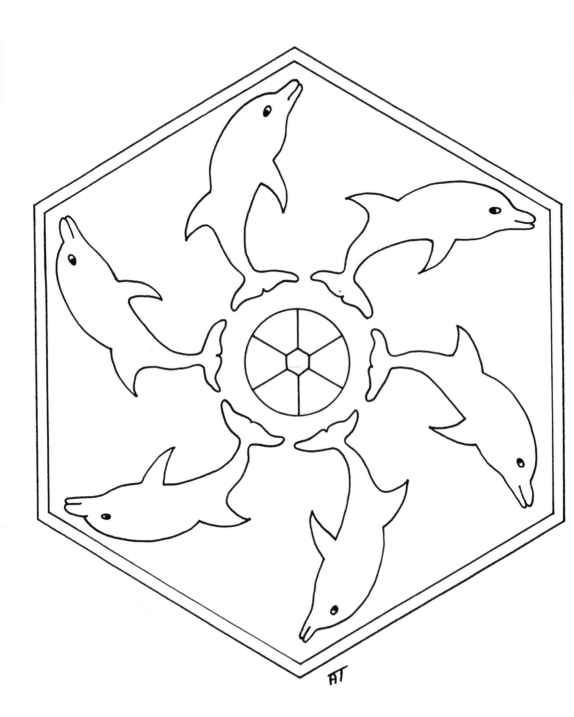

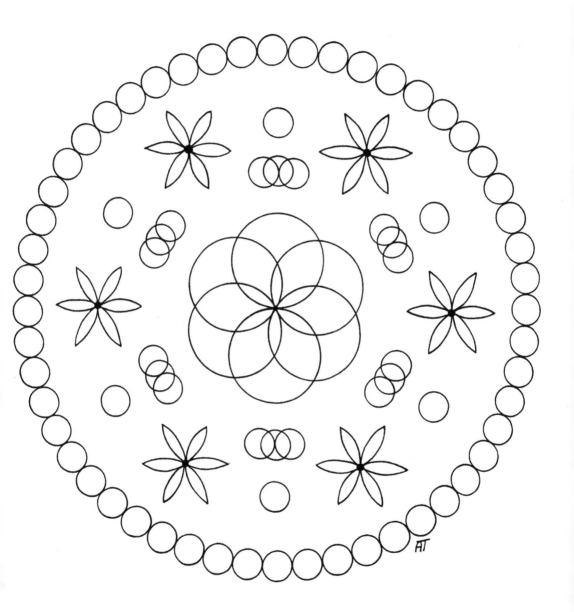

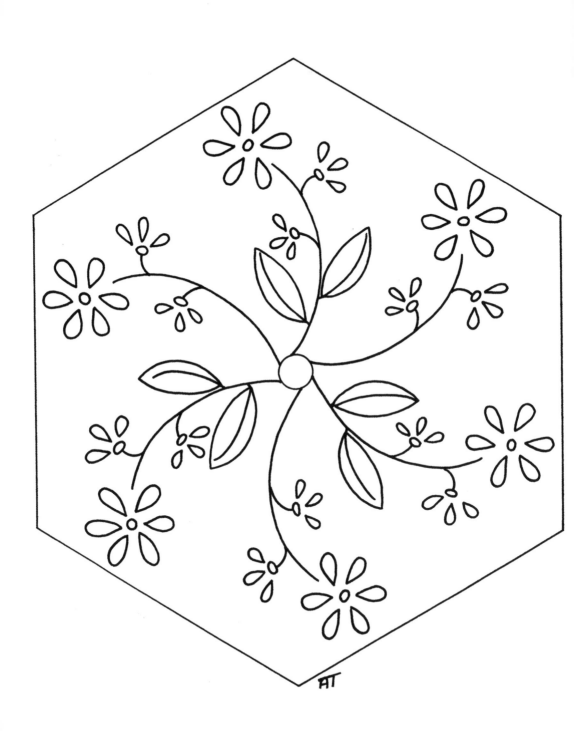

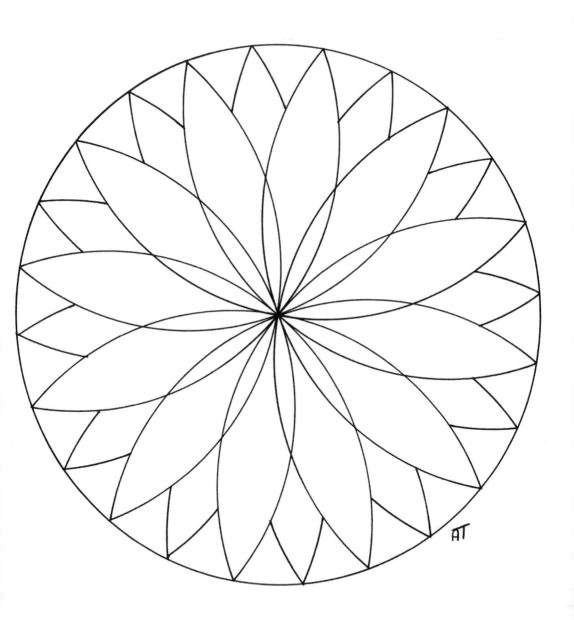

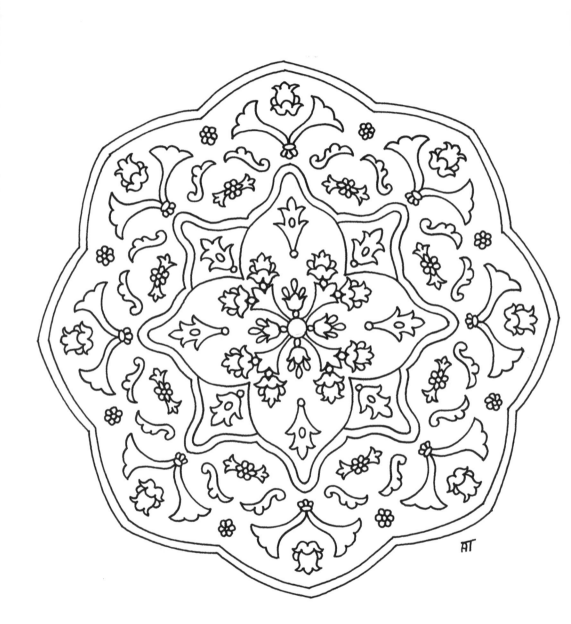

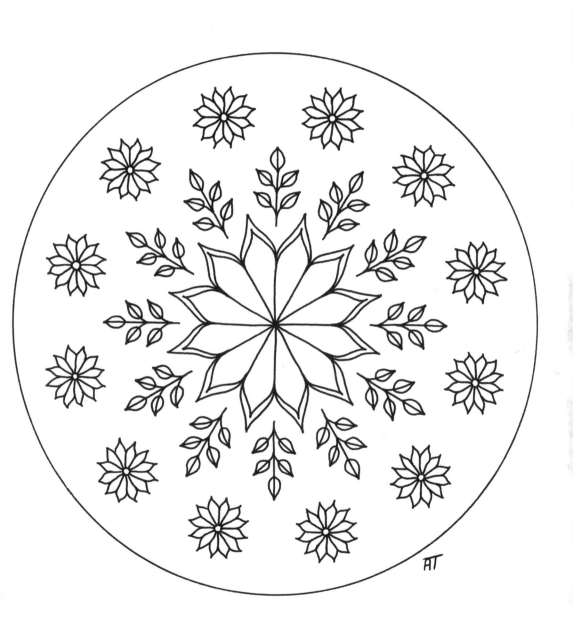

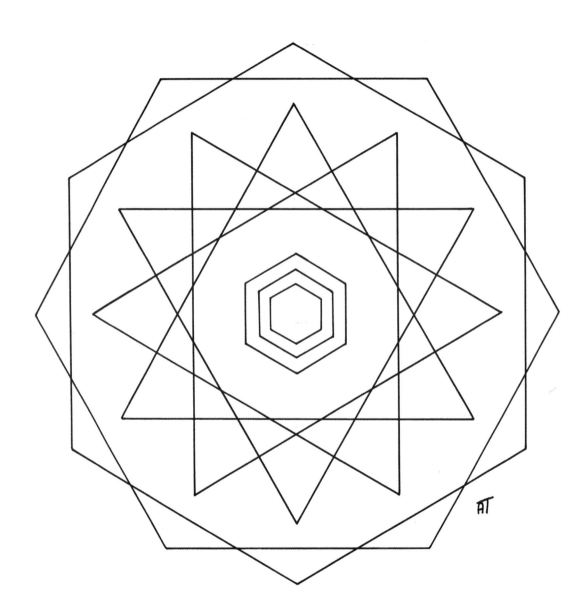

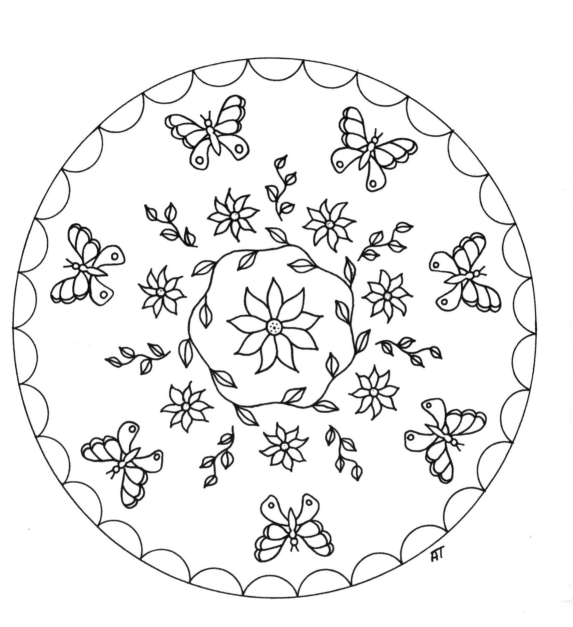

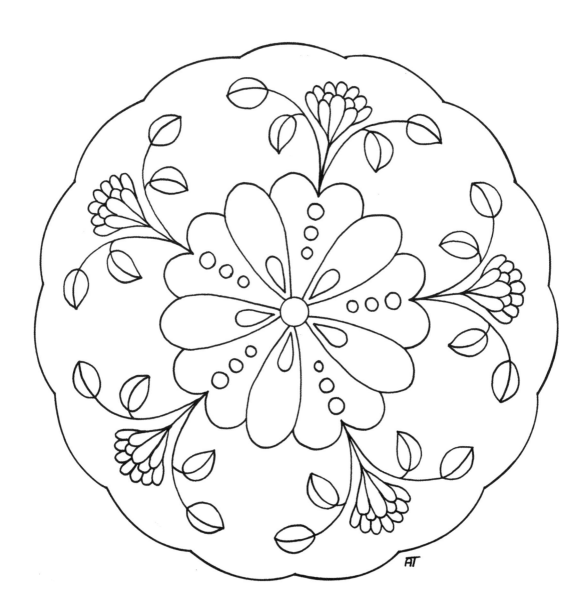

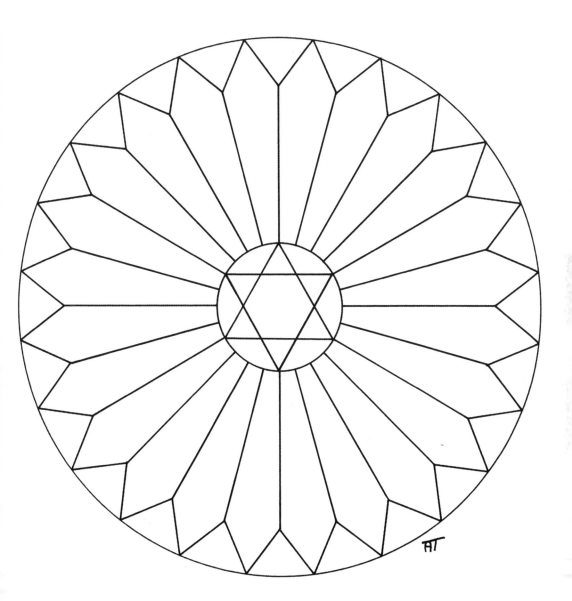